BP PORTRAIT AWARD 2011

National Portrait Gallery

Published in Great Britain by
National Portrait Gallery Publications
National Portrait Gallery
St Martin's Place, London WC2H 0HE

Published to accompany the BP Portrait
Award 2011, held at the National
Portrait Gallery, London, from 16 June to
18 September 2011, Wolverhampton
Art Gallery from 24 September to end
of October 2011 and the Aberdeen
Art Gallery from 12 November 2011 to
21 January 2012.

For a complete catalogue of current
publications please write to the address
above, or visit our website at
www.npg.org.uk/publications

ISBN 978 1 85514 449 1

A catalogue record for this book is
available from the British Library.

10 9 8 7 6 5 4 3 2 1

Head of Publications: Celia Joicey
Managing Editor: Christopher Tinker
Project Editor: Susie Foster
Design: Anne Sørensen
Production: Ruth Müller-Wirth
Photography: Prudence Cuming
Printed and bound in Italy
Cover: *Little Sister* by Tim Okamura
(detail; see page 55)

premier partner of the
London 2012 Cultural Olympiad

FSC
www.fsc.org
MIX
Paper from
responsible sources
FSC® C016114

CONTENTS

DIRECTOR'S FOREWORD

Judging the BP Portrait Award is a demanding but fascinating process of examination, discussion, evaluation and debate. Each year, a new set of portraits arrives in London from artists working throughout the UK and around the world. Each work is presented one by one to the judges. Anonymity is important, as the judges consider the actual paintings, but without knowledge of the artists' names. Over two days, there is a sifting down and a gradual closing in on the works selected for the exhibition and the prizewinners. In their devoted examination of another person, many of the artists demonstrate an attentive and affectionate regard for their sitters. As one judge put it, 'There is lot of love here.' However varied in approach, scale, technique and style, each selected work offers a chance to find something new in portraiture: a specific individual conveyed through the complex processes of putting paint on canvas or board. This is the fascination of a field of contemporary art that requires technical training and practice, and is centred on such a high level of skill.

2011 is the second year of the BP Portrait Award: Next Generation project, developed as part of the Cultural Olympiad. In its first year some excellent workshops took place, in which talented young people had the chance to work with prizewinners from previous years. Together with the summer family programme, the tour of the exhibition, the BP Travel Award and the annual commission, the whole BP Portrait Award project provides an opportunity to share contemporary painted portraiture of the highest standard with new and growing audiences.

The continuing support by BP for the competition, exhibition and Travel Award over twenty-one years is an example of outstanding arts sponsorship making a real difference to cultural development. My thanks go to Des Violaris, Ian Adam and other colleagues at BP, as well as to Bob Dudley, Chief Executive.

Sandy Nairne
Director, National Portrait Gallery

SPONSOR'S FOREWORD

The National Portrait Gallery houses the world's largest collection of portraits, from the sixteenth century to the present day. For the past twenty-one years, BP has been delighted to partner with the Gallery in support of its annual Portrait Award.

2011 has been another record-breaking year, with 2,372 entries from artists around the world. It is the artists' enthusiasm and aptitude to produce inspiring work that has made the BP Portrait Award one of the world's most prestigious art prizes. The competition culminates in a truly exciting public exhibition of the works, including those by artists shortlisted for prizes.

This year, in addition to the BP Portrait Award catalogue, a celebratory new book entitled *500 Portraits: BP Portrait Award* brings together more than 500 contemporary portraits selected from the entries since 1990, as well as those portraits that have been specially commissioned from the first prizewinners by the National Portrait Gallery.

In 2010, BP initiated a UK-based programme in support of the 'next generation' of talented portrait artists, providing summer-school opportunities for fourteen to nineteen year olds keen to expand their knowledge of portrait painting. BP Portrait Award: Next Generation will include venues outside of London in 2011 and 2012 as part of the BP Portrait Award tour.

My thanks go to all the artists who entered this year's BP Portrait Award, the judges and the outstanding team at the National Portrait Gallery who make the exhibition a joy to view. Congratulations to the winning artists.

Bob Dudley
Group Chief Executive, BP

Icons and Imagery: The Painted Portrait

Alison Weir
Historian and Novelist

My interest in portraiture ignited when I was a teenager. Having read a lurid novel about Henry VIII's wives, I hastened to the history books to find out the truth – and I've been seeking to discover it ever since. My initial fascination was with Anne Boleyn, the ultimate historical heroine in the widest romantic sense, and I have never forgotten my first visit to the National Portrait Gallery – a treasure house of wonders to an awestruck adolescent – where I came face to face with Anne's portrait by an unknown artist of the English school, which was painted late in the reign of Anne's daughter, Elizabeth I. And, having spent several decades since researching Tudor history and portraiture and arriving at a rather less romantic view of Anne Boleyn, I have to confess that I still find that image in the Gallery compelling and evocative. It entrances and it intrigues.

In this year, in which the Gallery has launched an appeal for the restoration of this portrait, it feels appropriate to take a view of it in its historical context. What does it convey to us? Why is it so iconic?

It may not be great art as we understand it today, but it is an important picture. Indeed, it is the definitive portrait of Anne Boleyn, one of the most famous queens in English history. Even though it is only one of several copies of a lost original painted from life between 1533 and 1536, it is the portrait by which most people identify Anne, and it captures the charm and wit of which her contemporaries spoke. It also bears testimony to the famous 'little neck' that was so soon to be severed by the executioner's sword, the eyes that were 'black and beautiful' and 'invited to conversation', and to her renowned elegance in dress. In short, the portrait, for me and – I know – for many, captures the essence of Anne Boleyn.

Purchased by the National Portrait Gallery in 1882 from the Reynolds Galleries, the portrait's previous provenance is unknown. It dates probably from the late sixteenth century, and was possibly part of a long gallery set of portraits of kings and queens painted for a great house, such sets being popular in Elizabethan and Jacobean England. It is clearly the image of a queen who wanted to make a statement. Our eyes are drawn to her 'B' pendant, one of several initial pendants that Anne favoured, which appear in portraits of her and Elizabeth. The painting proclaims her identity, and her sense of her own importance and that of her family. Along with the Latin inscription, which translates as 'Anne Boleyn, wife of Henry VIII', it tells us that, despite being of common stock and chosen for love rather than political advantage, this lady

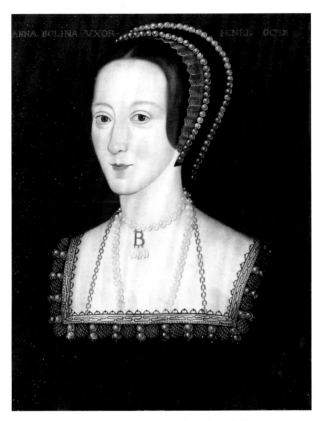

Anne Boleyn (1507–36) by an unknown artist, late 16th century (NPG 668)
Oil on panel, 543 x 416mm (21³/₅ x 16³/₈")

has achieved her long sought-after ambition and risen to the highest pinnacle that a woman can hope to attain. There is no hint here of the disaster yet to come.

There are rogue theories that the artist deliberately made Anne resemble Elizabeth, but the proliferation of other versions, as well as an image on a medal struck in 1534 – the only image known to date from the period of Anne's queenship – strongly suggest that the portrait is an accurate representation of what

she actually looked like. And probably Elizabeth did resemble her mother!

The multiplicity of this portrait type – at least fourteen versions exist – shows that there was renewed demand for likenesses of Anne Boleyn during the reign of Elizabeth, when Anne's memory was rehabilitated, a process that began almost as soon as Elizabeth succeeded to the throne in 1558. Anne's disgrace and execution in 1536 would account for the almost complete dearth of portraits dating from her lifetime; most were probably

destroyed, painted over or put away to rot. There have been absurd claims that Anne's dark hair, cold eyes, pale skin and black dress were contrived to make her look like a frightening wicked witch in her portraits, yet no subject was likely to display such a portrait in the political and cultural climate of Elizabeth's reign. One contemporary version of the portrait, at Hever Castle, Anne's family home in Kent, is unusual in that it shows her wearing a filet beneath her French hood (which also features in the version in The Deanery, Ripon, North Yorkshire), and it is the only one of this type to show her hands, holding a red rose. In the Hever portrait, fur cuffs replace the fur oversleeves seen in other versions.

The art of portraiture flourished in England in the early sixteenth century, thanks to the influence of two masters working at court, Lucas Horenbout, who specialised in portrait miniatures, and indeed introduced the form into England, and his exceptional pupil, the great Hans Holbein the Younger, whose portraits give us wonderful insights into a world long gone, and bring to life for us the great and the good of the early Tudor age. Unfortunately, no likeness of Anne Boleyn by Holbein exists.

Prior to this time, English portraiture had developed slowly through the later medieval period, mirroring the growth of realism in art, and there survive just a few early wood-panel images of royalty, some only known through later copies. But with the spread of diplomacy, the culture of the Renaissance and the propaganda of the 'New Monarchy'

of the Reformation, interest in portraiture escalated. In 1536, Henry VIII, the newly titled Supreme Head of the Church of England, commissioned from Holbein a mural depicting the Tudor dynasty for the Privy Chamber at Whitehall Palace. The mural was lost when the palace burned down in 1698, and is known only through later copies, but a preparatory drawing by Holbein, showing the King in a slightly different pose, survives in the Gallery's Collection. (The right-hand section of the drawing, showing Elizabeth of York and Jane Seymour, is lost.) The impact of the original mural is evident in the testimony of observers, who felt 'abashed and annihilated' on beholding the majestic figure of the King. There was an official impetus to disseminate Holbein's definitive 'state' portrait of Henry VIII, and the number of copies in existence testifies to a high demand, by those wishing to demonstrate their loyalty and approval of the new order, for portraits of the King.

After Holbein's death in 1543, no other court artist quite lived up to his genius. The latter decades of the sixteenth century saw the emergence of the 'costume portrait', a return to the two-dimensional portraiture of earlier decades, but with lavish attention to the details of dress, for the costume of the upper classes was fabulously expensive. This is the portrait as status symbol, not so much an attempt to portray the sitter as a real person, as a blatant advertisement of conspicuous consumption. There was no concept of 'less is more' in Tudor times: if you had it, you flaunted it, and the guiding principle was magnificence.

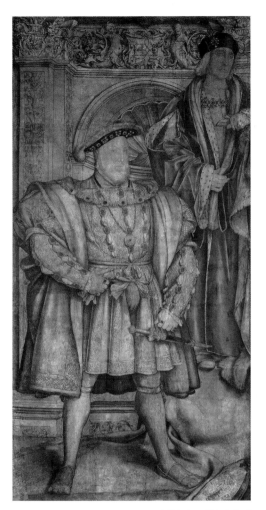

Henry VIII (1491–1547) and Henry VII (1457–1509) by Hans Holbein the Younger, c.1536–7 (NPG 4027)
Ink and watercolour, 2578 x 1372mm (101¹/₂ x 54")

Up until Holbein's time, most English painted portraits had been of royalty. They were icons of sovereignty. The Tudors had curbed the power of the aristocracy, and Henry VIII encouraged his nobility and courtiers to lavish their wealth on emulating his lifestyle, in order to divert them from spending it on private armies and subversive activities. Holbein's surviving oeuvre shows the diversity of his commissions, and demonstrates that the portrait had become an essential must-have status symbol for those connected with the court – and able to pay for it. Such commissions

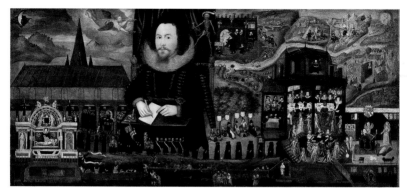

Sir Henry Unton (1557?–96) by an unknown artist, c.1596 (NPG 710)
Oil on panel, 740 x 1632mm (29$^{1}/_{8}$ x 64$^{3}/_{4}$")

may also have been a cover for Holbein's willingness to spy on those suspected by the government of disaffection from the political and religious status quo that followed the Reformation.

In an age long before the invention of photography, portraits had to be representational. That was their primary function. For example, in a period in which royal marriages were made for political advantage, portraits of the prospective partners could serve where a meeting was impossible.

But portraits then had many other purposes. They could project not only an image of a person, but also proclaim to the world how important that personage was. They could be given as gifts, signifying a material acknowledgement of favour and good service well done, or friendship towards a political ally. They were status symbols, proclaiming the wealth, importance and cultural sensitivities of their owners, and as such tell us much about the ego

and psychology of the sitters. They were painted to mark great events, or marriage, pregnancy and death. They were just one type of many handsome decorative artefacts in an age in which great houses were designed to impress. Dynasty and display were the watchwords.

Pictures themselves could convey messages: Tudor portraits reveal a whole language of symbolism and allegory, much of which has yet to be decoded. Thus, in the Hever portrait, the red rose held by Anne Boleyn symbolises love, affection, fertility and reverence for the dead. It betokened Anne's love for Henry VIII, her affection for her daughter, Queen Elizabeth, her fruitfulness in producing that daughter, and the reverence in which her memory was to be held. Such symbolism was implicit in heraldry, mottoes, dress, objects, stance, background, verses, or the ever-popular memento mori; some portraits were painted as emblems of remembrance, such as the biographical portrait of Sir Henry

Unton, commissioned by his wife, which combines much of this symbolism with a unique narrative of the subject's life. A lot can be inferred from 'reading' a Tudor portrait.

Today, it might seem that painted portraits have become an anachronism. They no longer need to be representational, since that function has been usurped by photography. Were Anne Boleyn alive today, it would be her photograph we would see, proliferating in every form of media.

But portraiture has been transformed radically with the advent of modern art. Since the end of the nineteenth century, discordant colours, distorted physical features and abstract or surreal settings have become its hallmarks. The painted portrait has had, of necessity, to become more artful, ensuring that its aesthetic appeal never fades.

Today, the portrait reaffirms our faith in icons. Like photography, it mythologises sitters, and yet it can convey so much more. A good artist looks beyond the public face to the character and soul of the subject, and can creatively portray that in an infinite number of ways. As Paul Klee, the Swiss abstract painter, said in 1920, 'Art does not reproduce the visible: rather, it makes visible.'

Yet surprisingly today's portraits still have much in common with their Tudor counterparts. Now, as then, portraits – such as that of Paul McCartney by Sam Walsh in the Gallery's Collection – make you a part of history instantaneously, no matter how influential or superfluous

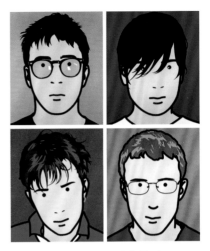

Blur: Graham Coxon (b.1969; top left); Alex James (b.1968; top right); Damon Albarn (b.1968; bottom left); Dave Rowntree (b.1964; bottom right) by Julian Opie, 2000 (NPG 6593(1–4))
C-type colour prints on paper laid on panel, each print 868 x 758mm (34$^{1}/_{8}$ x 29$^{7}/_{8}$")

you might be historically. Such images – even surreal ones – crystallise the past and leave it open to interpretation. They can create heroes, even though the truth may not be so heroic. Portraits can also be iconic: they can help to make you the face of a decade, such as the portrait of Blur by Julian Opie, much as Holbein's image of Henry VIII defined the decade of the Reformation.

Heads of state still commission painted portraits. They are symbols of power that separate the great and the good from ordinary mortals; they are visible evidence that the sitter is sufficiently important for someone to take the time to paint them, and that they are wealthy enough to pay for it. This too harks back to the Tudor age: it is the portrait as status symbol, and it has

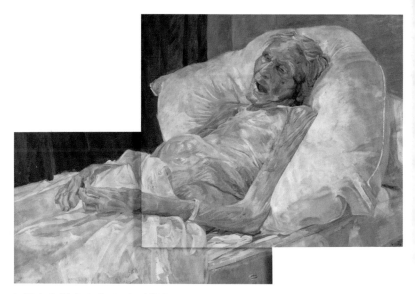

Last Portrait of Mother by Daphne Todd, 2010
Oil on wooden panels, 650 x 920mm (25½ x 36¼")

never gone out of fashion. And portraits of royalty and heads of state still hang in public buildings as expressions of loyalty.

But art is now more egalitarian, and modern portraits can be of anyone: politicians, film stars, writers, rock musicians, scientists, or even one's own mother on her death bed, which was the subject of the winner of the 2010 BP Award, Daphne Todd's *Last Portrait of Mother*. Even so, they can still feature the kind of symbolism, allegory and trickery that characterised Tudor portraiture.

Why are portraits so endlessly fascinating? It is because they are of people. We are conditioned from birth to be attracted to the human face, and as adults we remember

faces better than any other object. We learn so much of others from their faces: expressions and gestures project emotion and are crucially important to how we communicate with and judge each other.

Which brings us to the BP Portrait Award, the world's most prestigious portrait competition, acknowledged to be the ultimate showcase of the talents of aspiring artists and developments in portraiture, in which many have found success through submitting their work. The quality and diversity of the portraits displayed, the high standard achieved every year, and the exhibition's popularity with the public are proof that the ancient art of portraiture is alive and kicking still, and that it will flourish for centuries to come.

BP PORTRAIT AWARD 2011

The Portrait Award, in its thirty-second year at the National Portrait Gallery and its twenty-second year of sponsorship by BP, is an annual event aimed at encouraging young artists to focus on and develop the theme of portraiture in their work. The competition is open to everyone aged eighteen and over, in recognition of the outstanding and innovative work currently being produced by artists of all ages working in portraiture.

THE JUDGES

Chair: Sandy Nairne,
Director,
National Portrait Gallery

Iwona Blazwick, OBE,
Director, Whitechapel Gallery

Rosie Broadley,
Associate Curator,
National Portrait Gallery

Paul Emsley,
Artist (First Prizewinner in 2007)

Jonathan Jones,
Journalist and Art Critic

Des Violaris,
Director UK Arts & Culture, BP

THE PRIZES
The BP Portrait Awards are:

First Prize
£25,000, plus at the Gallery's discretion a commission worth £4,000.
Wim Heldens

Second Prize
£8,000
Louis Smith

Third Prize
£6,000
Ian Cumberland

BP Young Artist Award
£5,000
Sertan Saltan

PRIZEWINNING
PORTRAITS

Distracted
Wim Heldens

Oil on canvas,
750 x 550mm (29$^{1}/_{2}$ x 21$^{5}/_{8}$")

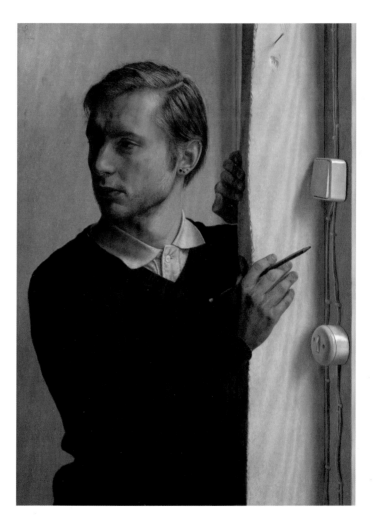

Holly
Louis Smith with help from Carmel Said

Oil on canvas,
3640 x 2430mm (143$^{1}/_{4}$ x 95$^{5}/_{8}$")

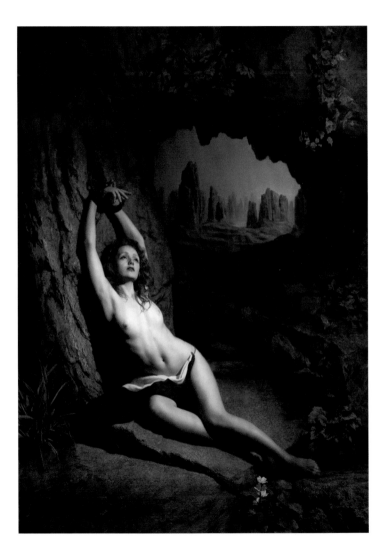

Just To Feel Normal
Ian Cumberland

Oil on linen,
1500 x 1000mm (59 x 39³/₈")

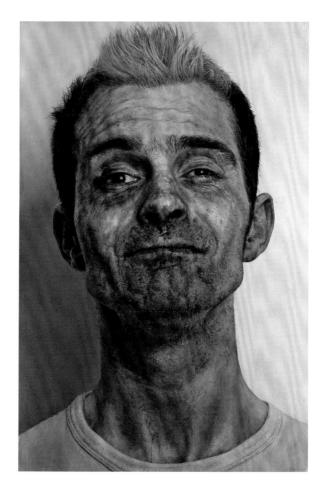

Mrs Cerna
Sertan Saltan

Oil on canvas,
510 x 410mm (20$^{1}/_{8}$ x 16$^{1}/_{8}$")

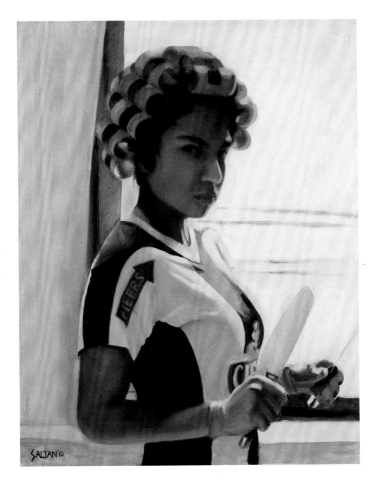

SELECTED
PORTRAITS

Ohh!
Cayetano de Arquer Buigas

Oil on canvas,
890 x 1160mm (35 x 45⁵/₈")

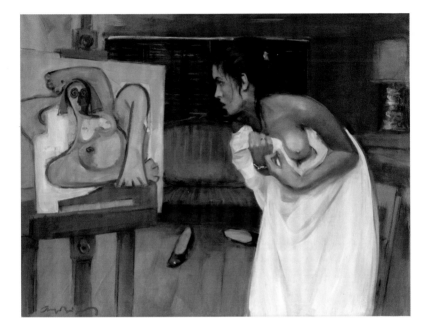

Sergio
Annalisa Avancini

Oil on linen,
1000 x 800mm (39$^{3}/_{8}$ x 31$^{1}/_{2}$")

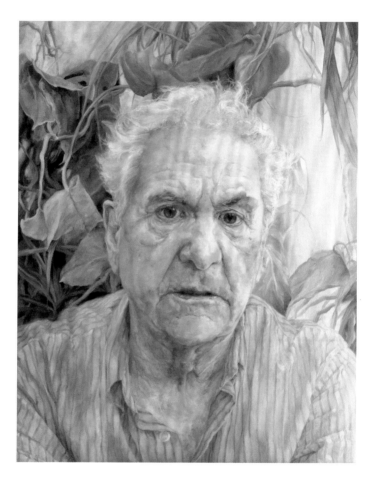

Yndia in Kente and Antique Dress
Noel Bensted

Oil on canvas,
1550 x 760mm (61 x 29$^7/_8$")

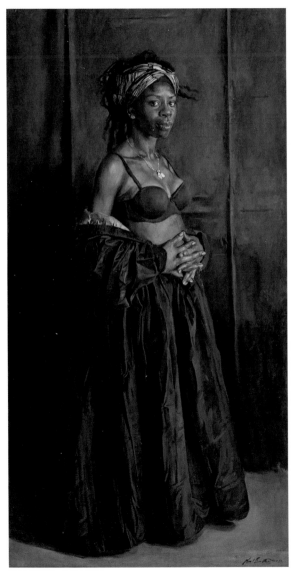

David Carter At Home
Richard Brazier

Oil on canvas,
1676 x 1168mm (66 x 46")

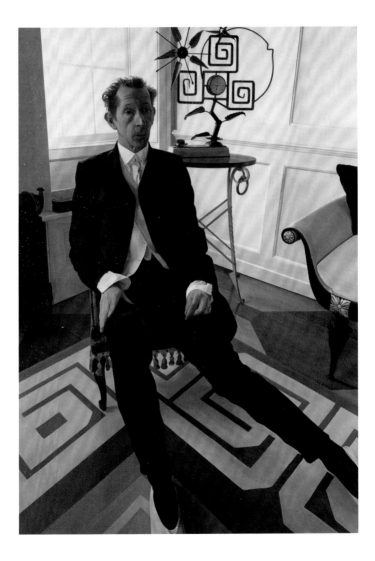

Daniel
Mark Bush

Acrylic on canvas,
914 x 457mm (36 x 18")

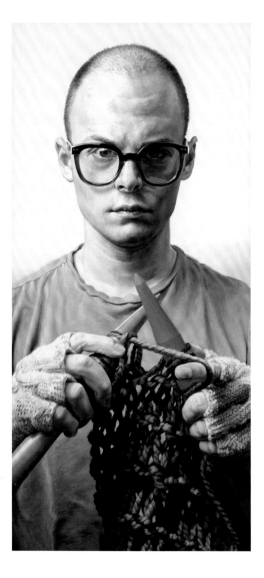

Teenage Dirtbag
Celie Byrne

Oil on canvas,
1220 x 1520mm (48 x 59$^{7}/_{8}$")

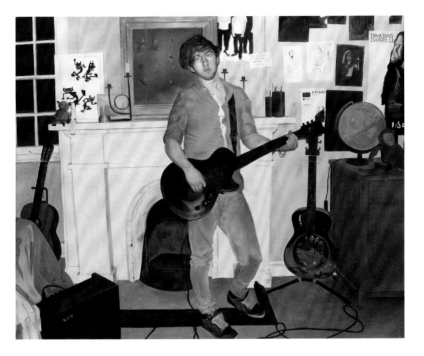

Mrs Bryan
Maria Carbonell

Oil on canvas,
500 x 1280mm (19$^5/_8$ x 50$^3/_8$")

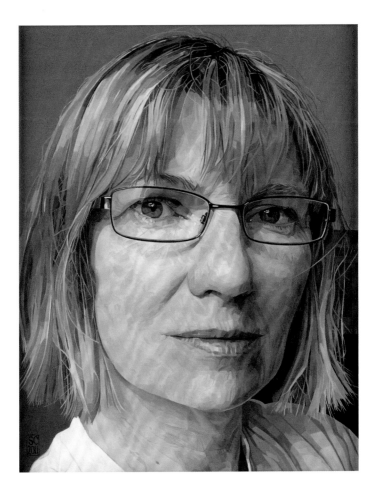

Latoya
Alan Coulson

Oil on panel,
406 x 306mm (16 x 12")

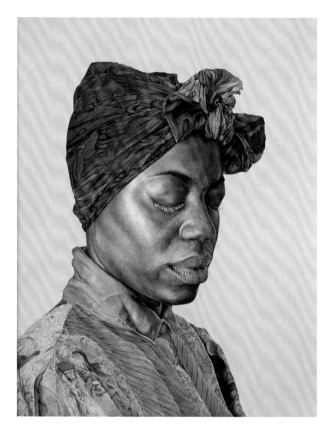

Thread the Light
(Portrait of Glen Hansard)
Colin Davidson

Oil on linen,
1270 x 1170mm (50 x 46$^1/_8$")

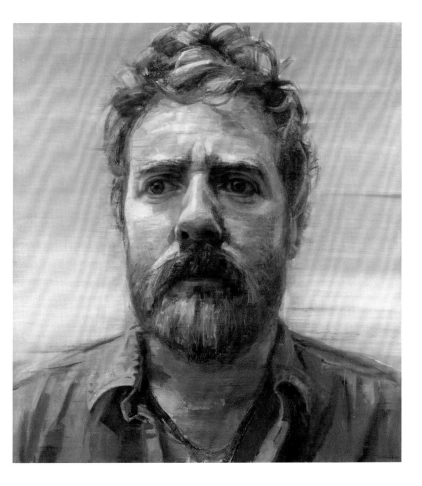

Detail after Reynolds
J.J. Delvine

Oil and acrylic on linen,
1000 x 600mm (39³/₈ x 23⁵/₈")

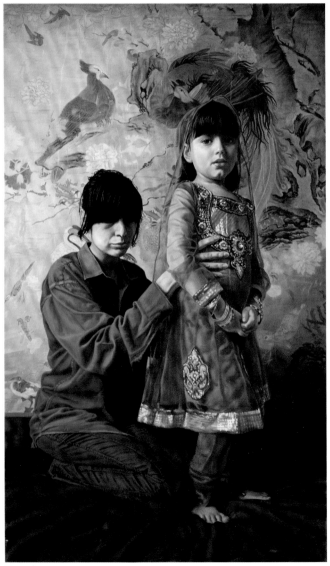

Goodbye dear Chón
Diaz Alamà

Oil on canvas on board,
1000 x 800mm (39³/₈ x 31¹/₂")

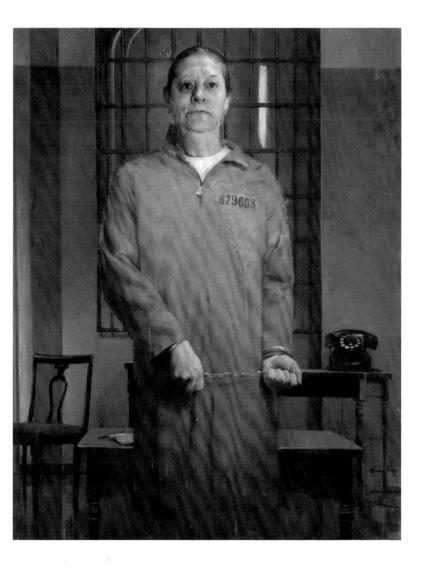

Courtney Pine
Daan van Doorn

Oil on panel,
1500 x 1500mm (59 x 59")

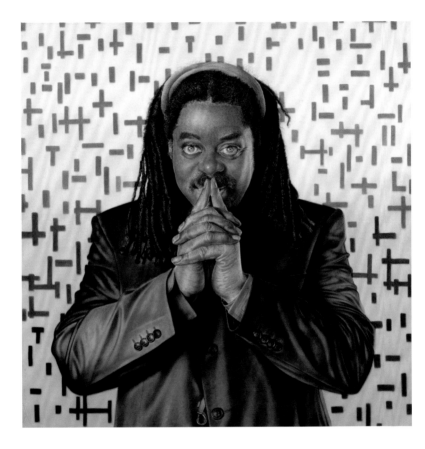

Jade (The Rehearsal)
David J. Eichenberg

Oil on panel,
diameter 482mm (19")

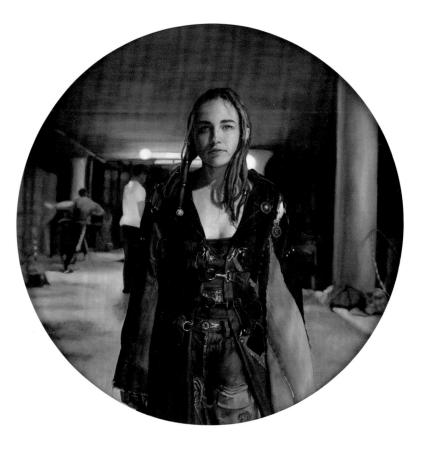

I could have been a contender
Wendy Elia

Oil on canvas,
1700 x 1300mm (66⁷/₈ x 51¹/₈")

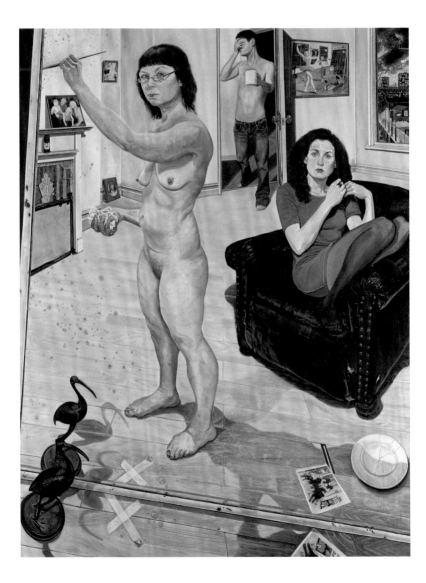

Despertar – Awakening
Manuel Ferrer Perea

Oil on canvas,
810 x 600mm (31$^{7}/_{8}$ x 23$^{5}/_{8}$")

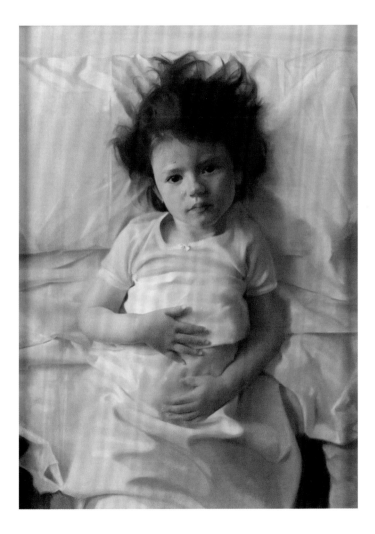

Michael Rosen, Patron of the
Little Angel Theatre, London
Lee Fether

Oil on linen,
625 x 720mm (24⁵/₈ x 28³/₈")

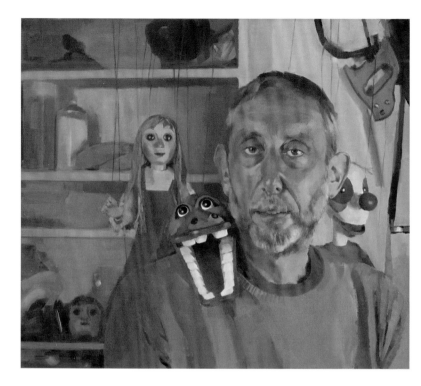

Peter Capaldi
Daniel Fooks

Oil on canvas,
1150 x 3250mm (45$^{1}/_{4}$ x 130")

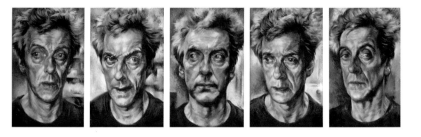

Abi
Nathan Ford

Oil on canvas,
280 x 200mm (11 x 7$^{7}/_{8}$")

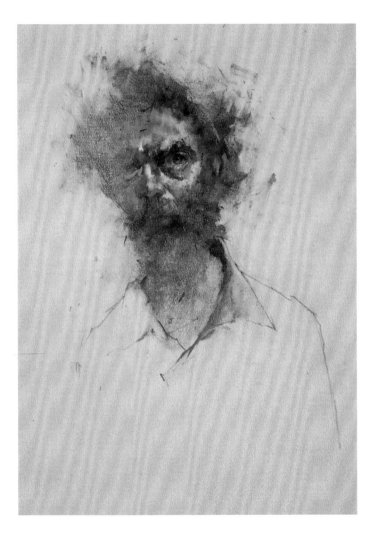

Flora MacGregor
Jo Fraser

Oil and charcoal on canvas,
1829 x 1219mm (72 x 48")

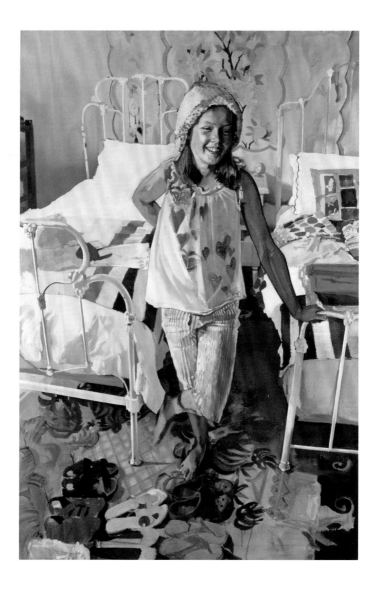

At this time of night
Al Freney

Oil on canvas,
1400 x 2000mm (55 1/8 x 78 3/4")

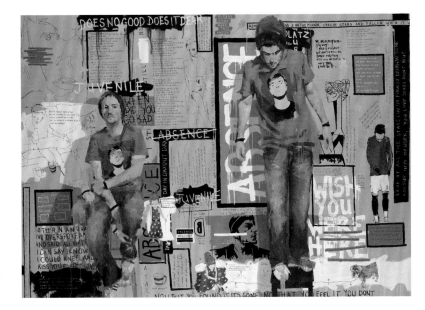

Brit Pop
Raúl G.

Acrylic and permanent marker on canvas,
1100 x 1500mm (43$\frac{1}{4}$ x 59")

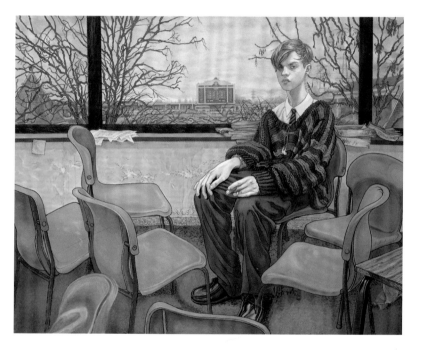

Portrait of my father
Tomas Georgeson

Oil on board,
300 x 230mm (11^{3}/$_{4}$ x 9")

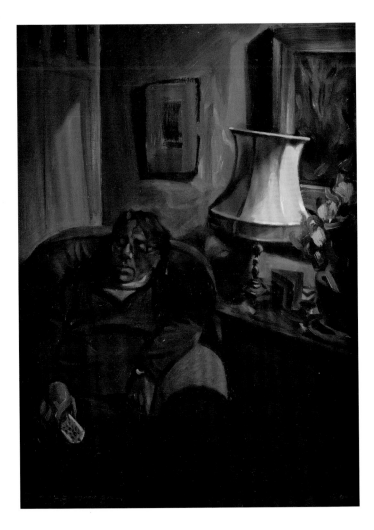

Scroobius Pip, Angles 2010
Leigh Glover

Oil on canvas,
1450 x 1100mm (57$^{1}/_{8}$ x 43$^{1}/_{4}$")

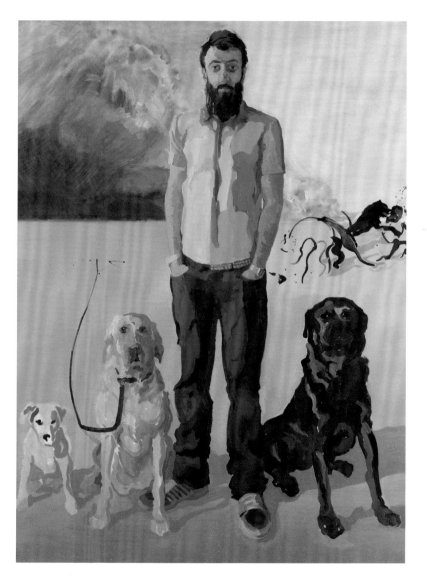

Take me home
Raoof Haghighi

Oil on canvas,
800 x 1000mm (31 $\frac{1}{2}$ x 39 $\frac{3}{8}$")

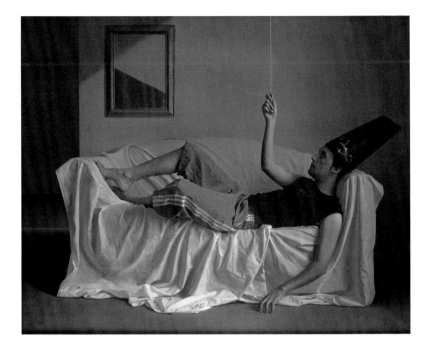

Mo and Kev
Chris Holt

Oil on canvas,
920 x 760mm (36$^{1}/_{4}$ x 29$^{7}/_{8}$")

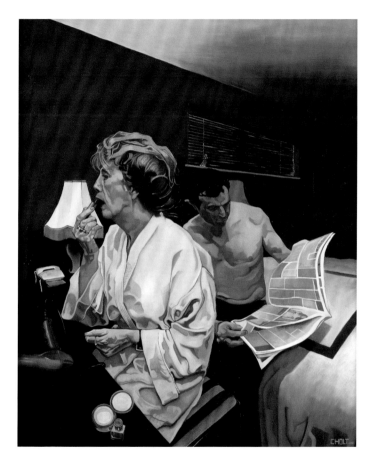

In the Morning
Agita Keiri

Oil and acrylic background on canvas,
900 x 900mm (35³/₈ x 35³/₈")

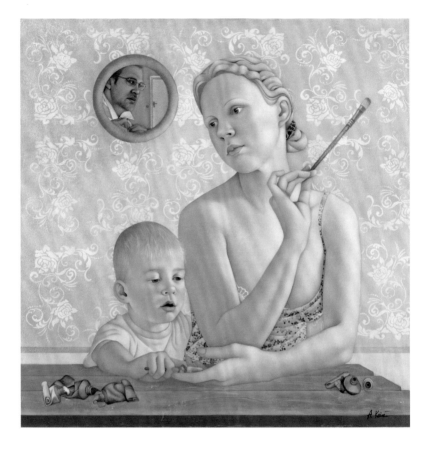

George O'Dowd
Layla Lyons

Oil on canvas on wooden stretcher,
1800 x 1400mm (70$^7/_8$ x 55$^1/_8$")

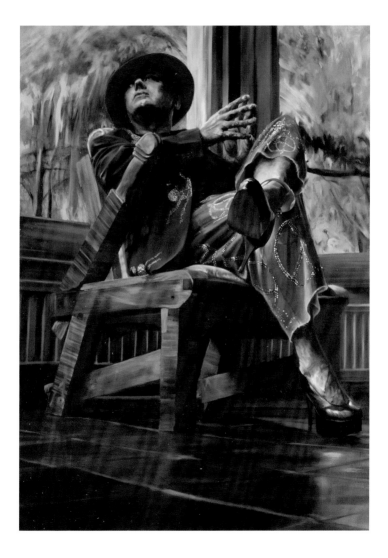

He who dares, portrait of AP McCoy
Jennifer McRae

Oil on linen,
1270 x 1020mm (50 x 40⅛")

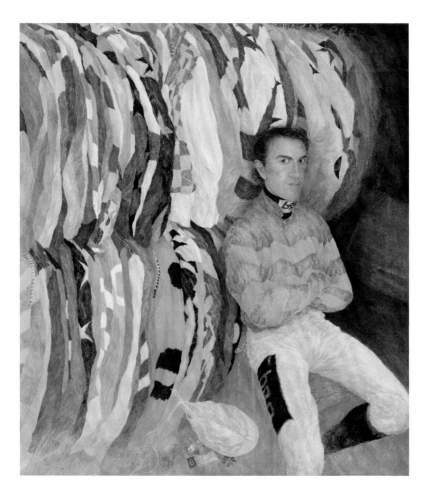

Howard Zinn –
A People's Historian (1922–2010)
Raoul Martinez

Oil on canvas,
1270 x 864mm (50 x 34")

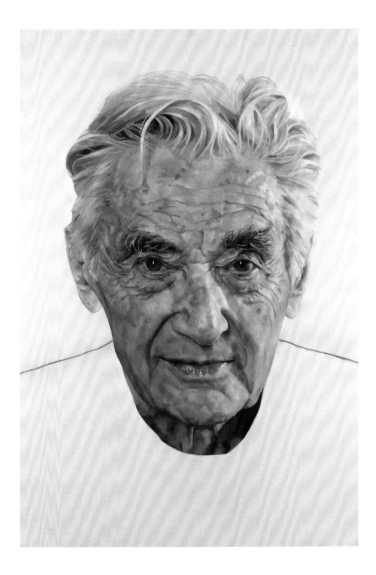

Jakub
Jan Mikulka

Oil on canvas,
1000 x 700mm (39$^{3}/_{8}$ x 27$^{1}/_{2}$")

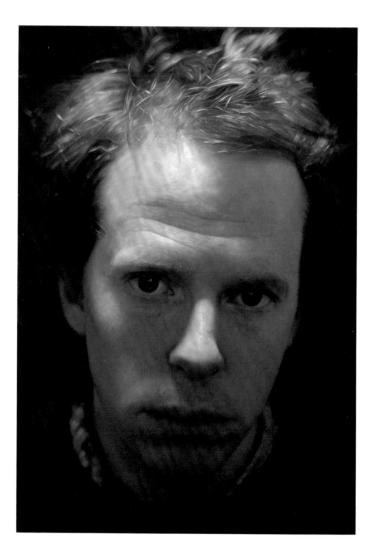

The Shooting Gallery – Members
of the Batley & District Gun Club
Tony Noble

Acrylic on board,
1420 x 1020mm (55$^{7}/_{8}$ x 40$^{1}/_{8}$")

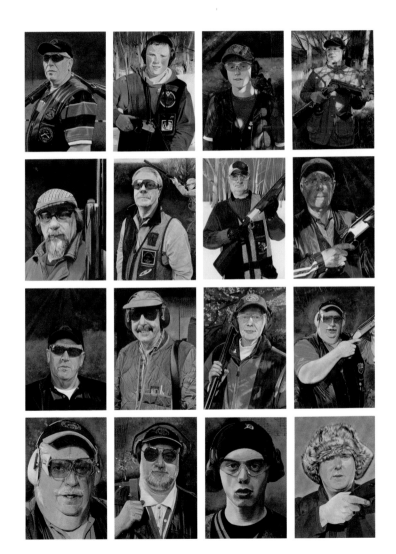

My Son Benjamin,
The Lord of the Rings
Istvan Nyari

Acrylic on canvas,
1500 x 2000mm (59 x 78³/₄")

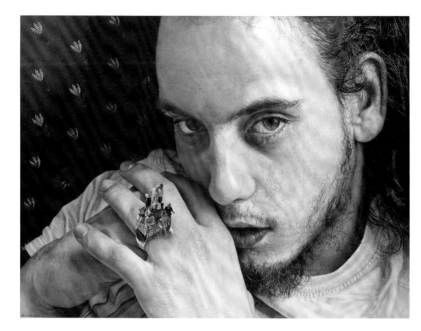

Little Sister
Tim Okamura

Oil on canvas,
2184 x 1625mm (86 x 64")

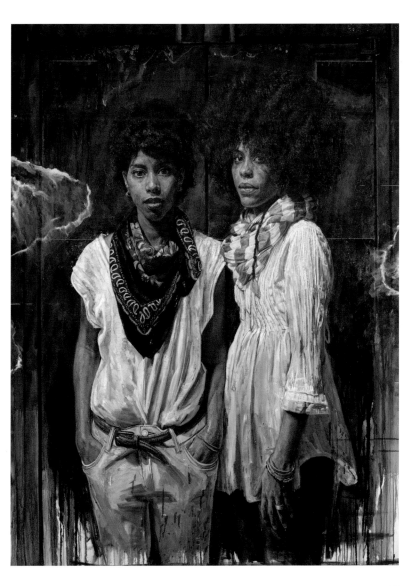

Oil on canvas,
300 x 250mm (11³/₄ x 9⁷/₈")

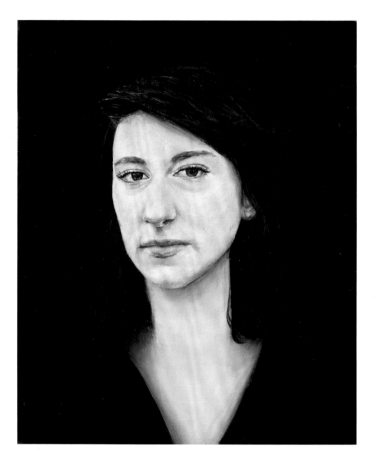

R.H.
Isobel Peachey

Oil on canvas,
813 x 610mm (32 x 24")

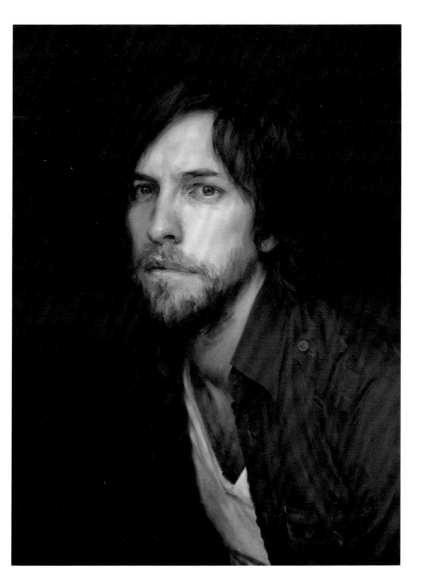

Self-portrait (Triptych)
Thea Penna

Acrylic on canvas,
302 x 606mm (11$^{7}/_{8}$ x 23$^{7}/_{8}$")

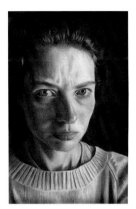 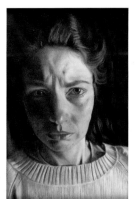 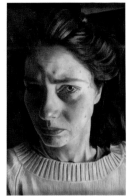

The Evil murdering misguided
Queen Cassandra
Louise Pragnell

Oil on canvas,
1103 x 806mm (43³/₈ x 31³/₄")

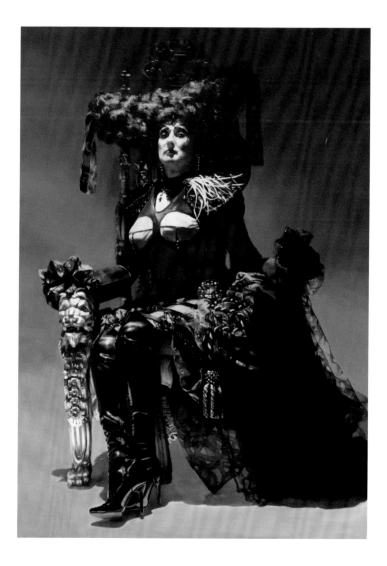

Sunbathing
Olha Pryymak

Oil on panel,
360 x 280mm (14$^{1}/_{8}$ x 11")

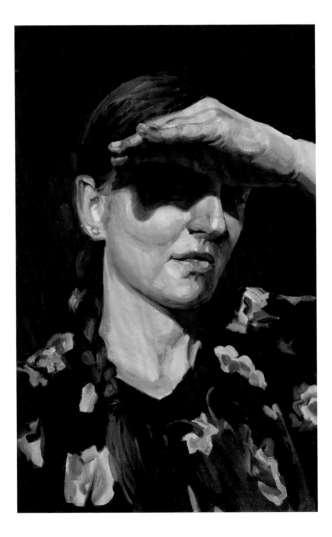

Departure
Angela Reilly

Oil on canvas,
1168 x 965mm (46 x 38")

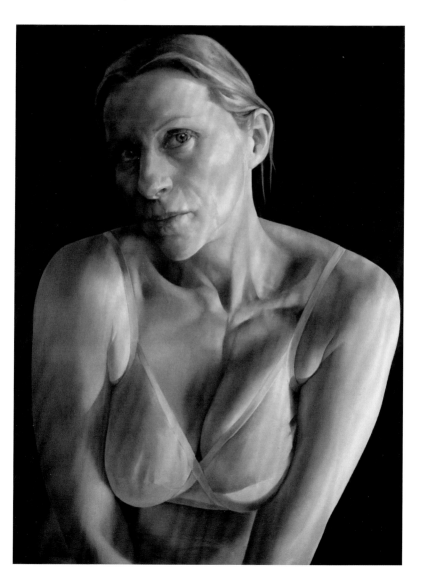

Lauren and Dexter
Philip Renforth

Oil on linen on board,
1300 x 950mm (51 $^1/_8$ x 37 $^7/_8$")

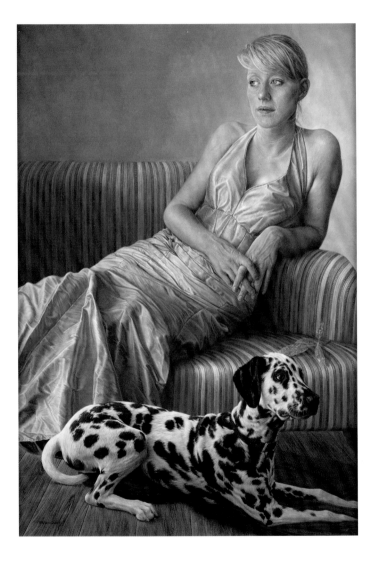

La nena (little girl)
SACRIS

Oil on canvas,
1650 x 1000mm (65 x 39³/₈")

Six Decades
Matthew Schofield

Oil on Mylar on panel,
102 x 737mm (4 x 29")

Self Portrait
Fiona Scott

Oil on canvas,
910 x 610mm (35⁷/₈ x 24")

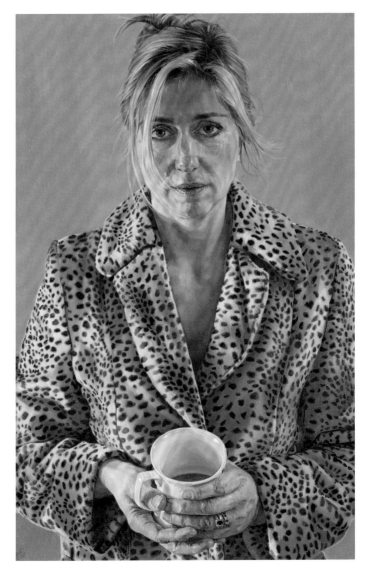

Father and I, Life Size
Elie Shamir

Oil on canvas,
2060 x 3200mm (81 1/8 x 126")

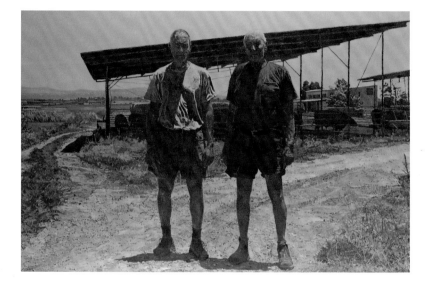

Maxi Jazz
Joe Simpson

Oil on canvas,
600 x 600mm (23⅝ x 23⅝")

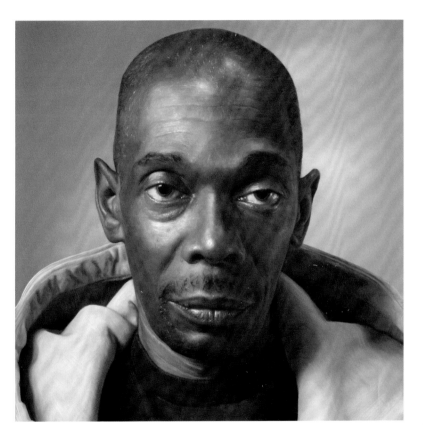

Katherine (and Millie)
Barbara Skingle

Oil on canvas,
457 x 356mm (18 x 14")

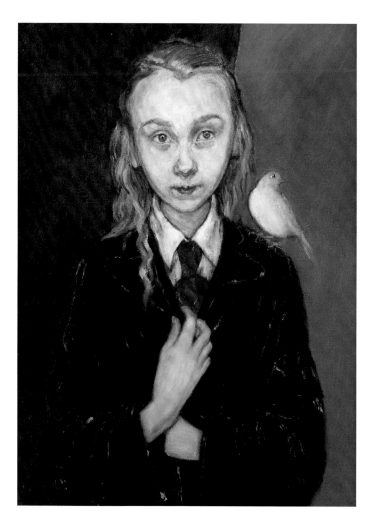

Study
Benjamin Sullivan

Oil on canvas,
750 x 300mm (29^1/$_2$ x 11^3/$_4$")

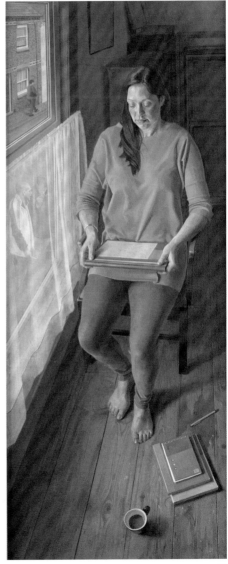

Glenda Jackson
Edward Sutcliffe

Oil on wooden board,
800 x 550mm (31$^{1}/_{2}$ x 21$^{5}/_{8}$")

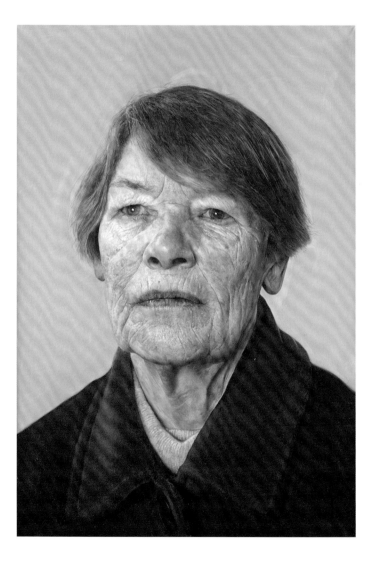

Wanderflower
Harriet White

Oil on board,
1200 x 1200mm (47$^{1}/_{4}$ x 47$^{1}/_{4}$")

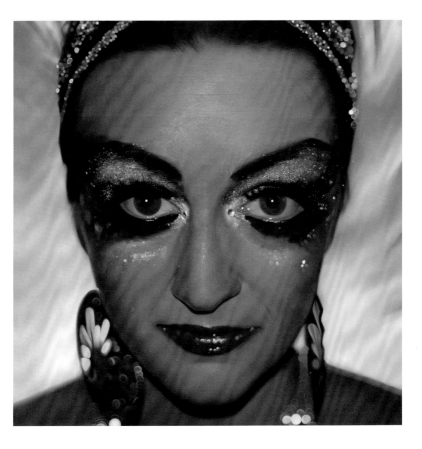

Venus as a boy
Wen Wu

Oil on canvas,
2400 x 1450mm (94$^{1}/_{2}$ x 57$^{1}/_{8}$")

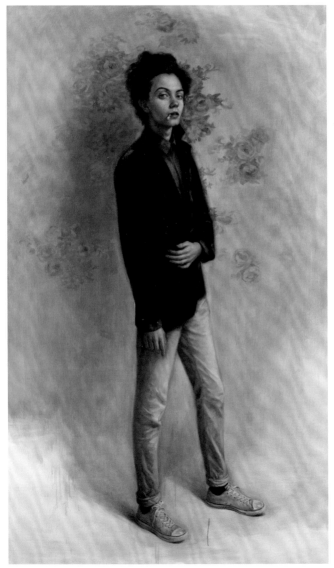

BP TRAVEL AWARD 2010

Each year exhibitors are invited to submit a proposal for the BP Travel Award. The aim of this award is to give an artist the opportunity to experience working in a different environment, in Britain or abroad, on a project related to portraiture. The artist's work is then shown as part of the following year's BP Portrait Award exhibition and tour.

THE JUDGES

Liz Rideal,
Art Resource Developer,
National Portrait Gallery

Des Violaris,
Director, UK Arts & Culture, BP

Flora Fricker,
Exhibition Manager,
National Portrait Gallery

The Prizewinner 2010
Paul Beel, who received £5,000 for his proposal to travel to Mirtiotissa, a nudist beach on the Greek island of Corfu.

BEACH PAINTING ODYSSEY

In September 2010 the BP Travel Award took me to Mirtiotissa, a nudist beach on Corfu, where I painted a large-scale canvas and shot video of the experience. The idea for this project came eleven years ago when I visited the beach on my honeymoon. It had attracted a fascinating mixture of the nude and the clothed, single people and families, young and old, straight and gay. That summer on the beach I made my first small *plein air* painting of a feature I've dubbed Elephant Rock. The sketch lacked people, who would have added the essential texture of life to this striking natural scenery, and I knew I wanted to return one day to populate the piece with a mass of naked beachgoers. Over the following years Mirtiotissa became personified in my mind as an enchanted siren, softly calling me to her from across the sea.

My portraits are never straightforward likenesses; rather, they are concerned with the sense of their sitters being participants in a great drama of humanity. Corfu gave me the potential to explore this sensibility on a much grander scale. To do this, I decided to live the experience like an ancient hero from Greek myth, by creating absurd physical challenges for myself and performing in public what the layperson sees as almost magical acts of artistic creation. I was aware that this path was taking me dangerously close to that most tragic

failure: hubris. But while in Greece, I reasoned, do as the Greeks did.

I went with two ideas: the project must be executed with Spartan discipline and exhaustive logistical planning, and, conversely, the art itself would depend utterly on the moment as the beach and its community defined it. I began preparing my journey two months in advance, researching the beach, designing and building custom equipment to reach it with all my painting supplies at hand (most importantly a painting cart, which I considered my chariot), and began exercising seriously for the first time in fifteen years.

On 1 September I set off with painter Pietro Manzo – my travelling companion, fellow mule, critic and kindred spirit – strapping the three canvases to the roof of his car and loading it with supplies. While not a very devoted cameraman (his original job description), Pietro was always there to back me up. He made this trip possible, and I wouldn't trade him for a golden fleece. We drove to Venice, where we would embark on the twenty-seven-hour crossing of the Ionian Sea aboard the *Sophocles III*, adding the first lines of drama to my play with a spectacular view of the sunset over the Piazza San Marco.

I was nervous during the crossing, with good reason. Margaux, a former

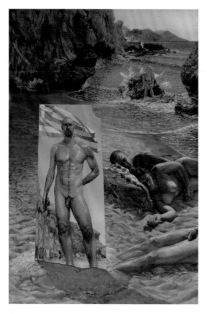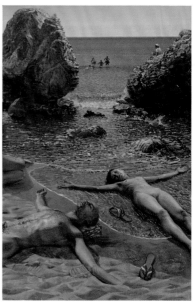

Epic Mirtiotissa (work in progress) by Paul Beel, 2011
Oil on linen, 2000 x 5330mm (78³/₄ x 209⁷/₈")

student of mine who now wrote MTV reality shows, was to fly in from the United States the following day to be the first model. The night before leaving, she messaged me, cancelling her plans.

One of my biggest fears was having no models in the first week, and Margaux's news cast pessimism on the trip's success. I had brought a large mirror along. If the worst came to the worst, I could always start with a self-portrait. It was not the best back-up plan and might isolate me on the beach, rather than inviting sitters, but it was better than nothing.

A week later a package arrived for me. Margaux had sent the large, floppy hat she had bought for her portrait, saying that this way she was

there in spirit. Her hat now floats in the third canvas.

We disembarked in Corfu Town and drove the short distance across the island, arriving at Panorama Rooms around midnight on 3 September. Anxious finally to see the beach, we trekked down in the moonlight. After a ten-year absence I was shocked to find that Mirtiotissa was unrecognisable. Once a vast expanse of sand, the beach was now about fifty metres long and ten wide.

In the month that followed I saw that despite her ravaged dimensions she was the same as ever, with beautiful, crystal-clear water, litter-free, tranquil, and frequented by wonderful people. Her spirit remains unchanged.

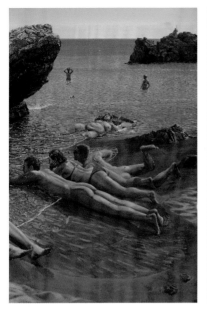
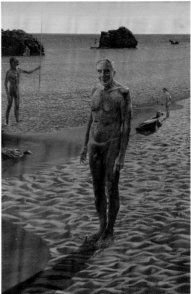

I woke before dawn, packed my gear and headed down the hill, having just enough time to receive chilly vibes from the beach vendors, set up the canvases, and rough out the major rocks and the sea before it started raining. While packing up we met Franco, an Italian from Bari – mid-fifties, tattooed and burnt to a crisp. We went for lunch and beer. Franco convinced the restaurant to park my cart in their storage room, and was the first to volunteer to sit.

While it rained I spent time getting to know the neighbours. Heidi and Natasha, a German mother and her eighteen-year-old daughter, were staying at Panorama Rooms with us. We shared dinner and ouzo that first rainy night and Natasha agreed to sit for me. The first three days were

menacing: a tiny beach, bad weather and eviction from my parking at the restaurant tried my resolve. The eyes on the beach regarded me as an invader and distrusted my motives for being there. I needed a break. Natasha was it.

She had been coming to Mirtiotissa since she was four, and everyone there loved her. She sat like a sculpture, refusing drinks and nodding only slightly to give Heidi permission to apply sunscreen. After I'd painted Natasha, locals who just two hours before had spoken only Greek – and in one case, smacked the canvases with a bamboo pole – now spoke English and ordered people out of the way so I could observe the next model out in the waves. Natasha was manna from

heaven and I quickly acquired a loosely scheduled waiting list. The first week raced by and soon Graham, another former student of mine, arrived from London. He spent the next five days modelling for his full-scale portrait, laying with arms spread to receive the sunshine in the foreground, providing an important compositional diagonal and lending his poignantly delicate masculinity to the work. While I was working on Graham, I also began Adelle's portrait. Adelle was a slender, milky-white Romanian woman with red hair. As she sat for her portrait, she told me that the night before she had a vision of me painting her while I listened to one of her favourite songs. Relishing the opportunity for self-fulfilling prophecy, I plugged in her iPod and went to work.

In the weeks that followed I worked with many models, some for just fifteen minutes and some for days. While daytime on the beach was filled with manic energy, the sunrise and sunset hours provided time for quiet meditation on light and nature as I filmed the change of the day. Nights were passed with hardy Greek dinners, laughing with new friends and video screenings.

Making the painting was a month-long improvisation, as weather, willing models and high waves are unpredictable variables. All compositional choices were made on the fly, taking each day as it came, always some routine and some surprises. The painting shows a compression of my time there, with morning hours generally on the left and afternoon generally on the right. I saw my job as facilitating a situation where making the painting was possible, but it was Mirtiotissa and her sunbathers who shaped it. It is not a group portrait nor a seascape nor a genre painting, but a portrait of a place.

At one point I decided to add a fourth panel to the composition. Built on location by Pietro and stretched with local sailcloth, it allowed for more figures and opened the horizon. As the waves rose and continuously eroded the beach I often had to work in the courtyard behind the Panorama Rooms, and just as space on the real beach diminished, so it also did in my picture, until it threatened to nearly push out into the viewer's space.

The last full-scale figure to enter the painting was Andreas, a former bank executive in his mid-seventies, who makes the steep walk to the beach every day just before sundown for an afternoon swim in the nude. This he has done daily for the last thirty years, always in white, from his hair to his shoes. The day after a late-September tempest devastated the beach, high waves washed away Andreas's clothes. It was the first time in twenty years that Andreas left the beach wearing not unvaried white, but black (a hastily obtained replacement pair of trousers). I don't believe in signs, but while in Greece I did believe in messages from the oracle, and couldn't help but wonder if his funereal dress might be a dark omen for the fate of the beach. Was my picture to be a eulogy of the last, gorgeous September of sand on Mirtiotissa?

Paul Beel

ACKNOWLEDGEMENTS

My first thanks go to the artists, from all parts of the world, who decided to enter work for the 2011 Award. Congratulations go to all the artists included in the exhibition, and special praise for the prizewinners, Wim Heldens, Louis Smith and Ian Cumberland, and to Sertan Saltan, the winner of the prize for a younger painter.

Thanks go to my fellow judges: Iwona Blazwick, Rosie Broadley, Paul Emsley, Jonathan Jones, and Des Violaris. They were brilliantly critical and frank in their opinions on this large entry, and were open and attentive through the whole selection process. I am also grateful to the judges of the BP Travel Award: Liz Rideal, Des Violaris and Flora Fricker. I would like to offer my thanks to Alison Weir for her catalogue essay, which intriguingly links her historical studies with contemporary portrait painting.

I am very grateful to Susie Foster for her editorial work, Anne Sørensen for designing the catalogue and also to Michelle Greaves for her overall management of the 2011 BP Portrait Award exhibition. My thanks also go to Michael Barrett, Pim Baxter, Stacey Bowles, Nick Budden, Denise Ellitson, Neil Evans, Ian Gardner, Celia Joicey, Matthew Lewis, Justine McLiskey, Ruth Müller-Wirth, Doris Pearce, Jude Simmons, Liz Smith, Christopher Tinker, Sarah Tinsley, and other colleagues at the National Portrait Gallery for all their hard work in making the project such a continuing success. My thanks also go to the white wall company for their excellent contribution to the management of the selection and judging process.

Sandy Nairne
Director, National Portrait Gallery

INDEX